ONE DIRECTION

The Official Annual 2015

HarperCollins*Publishers*

HarperCollins*Publishers*
77–85 Fulham Palace Road,
Hammersmith, London W6 8JB

www.harpercollins.co.uk

First published by HarperCollins*Publishers* 2014

10 9 8 7 6 5 4 3 2 1

© 1 D Media Limited, 2014

Text: Sarah Delmege
Design: Ben Gardiner

One Direction's official photographer is Calvin Aurand. Calvin Aurand is a music-industry executive turned live music filmmaker and photographer. For the past 30 months he has toured with One Direction, using his unique perspective and behind-the-scenes access to document the band's travels around the globe. For more information visit www.krop.com/calvinaurand.

All photographs © Calvin Aurand, with the exception of Instagram images courtesy of Modest! Management and One Direction.

While every effort has been made to trace the owners of copyright material reproduced herein and secure permissions, the publishers would like to apologize for any omissions and will be pleased to incorporate missing acknowledgements in any future edition of this book.

A catalogue record of this book is available from the British Library

ISBN 978-0-00-757735-4

Colour reproduction by FMG
Printed and bound in Italy by L.E.G.O S.p.A.

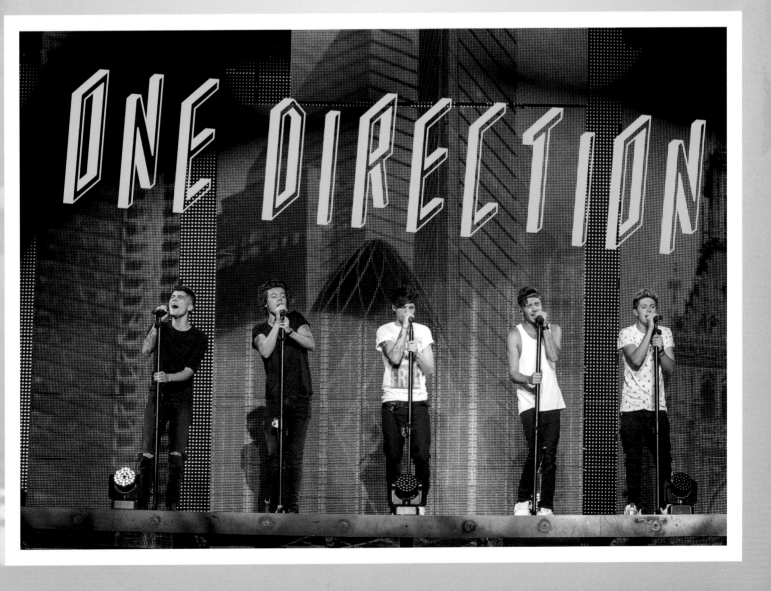

CONTENTS

Best Band Ever

One Direction are the biggest and most loved boy band the world has ever known. They've taken the whole planet by storm. In four short years they've achieved the kind of success that other bands can only dream of. With the eyes of the globe upon them, Harry Styles,

Liam Payne, Louis Tomlinson, Niall Horan and Zayn Malik have gone from young boys next door to fully fledged rock stars. The boys just keep on reaching for greater heights, constantly pushing themselves to keep on achieving. The band have produced hit after amazing hit, securing some of the world's biggest-selling releases of the past four years.

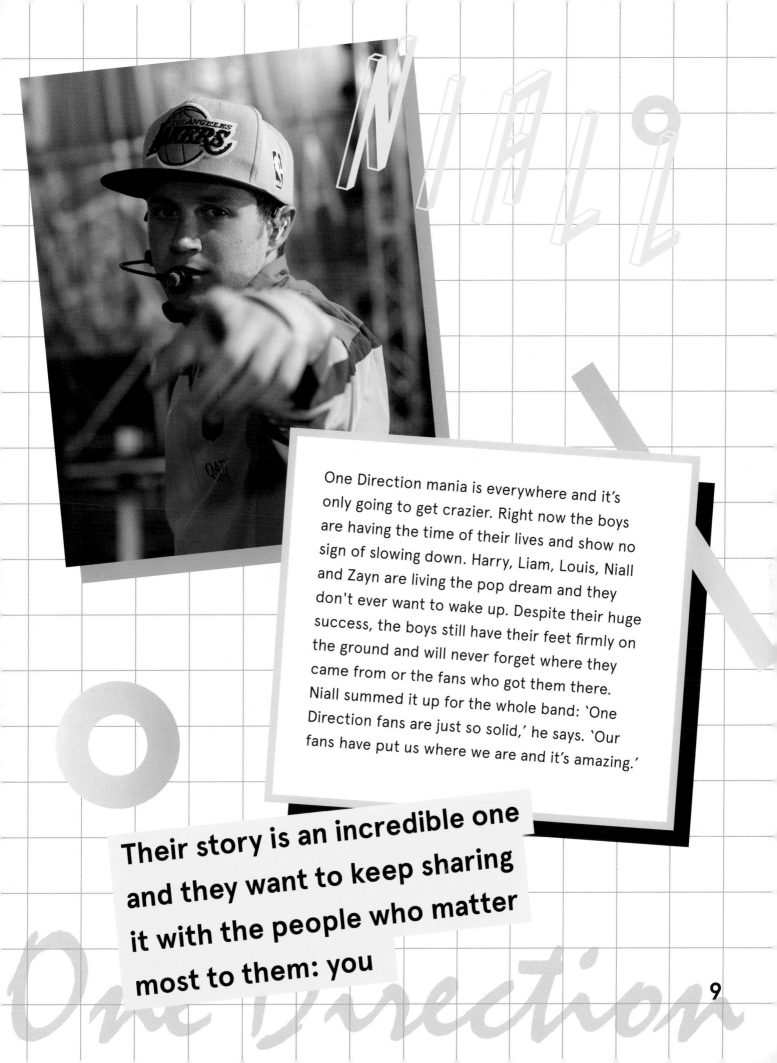

One Direction mania is everywhere and it's only going to get crazier. Right now the boys are having the time of their lives and show no sign of slowing down. Harry, Liam, Louis, Niall and Zayn are living the pop dream and they don't ever want to wake up. Despite their huge success, the boys still have their feet firmly on the ground and will never forget where they came from or the fans who got them there. Niall summed it up for the whole band: 'One Direction fans are just so solid,' he says. 'Our fans have put us where we are and it's amazing.'

Their story is an incredible one and they want to keep sharing it with the people who matter most to them: you

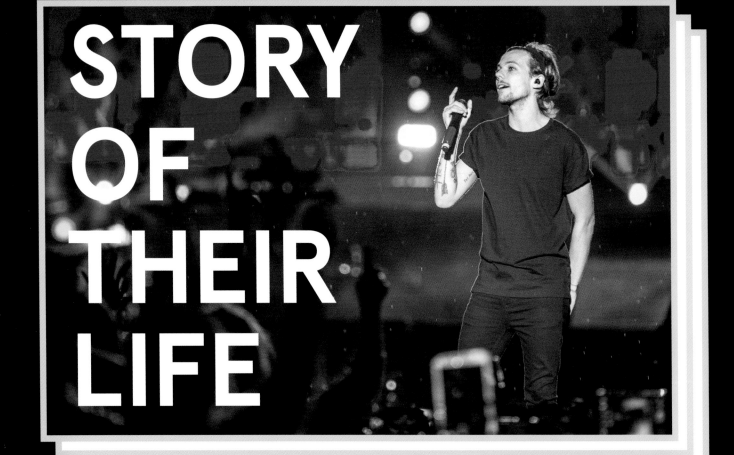

STORY
OF
THEIR
LIFE

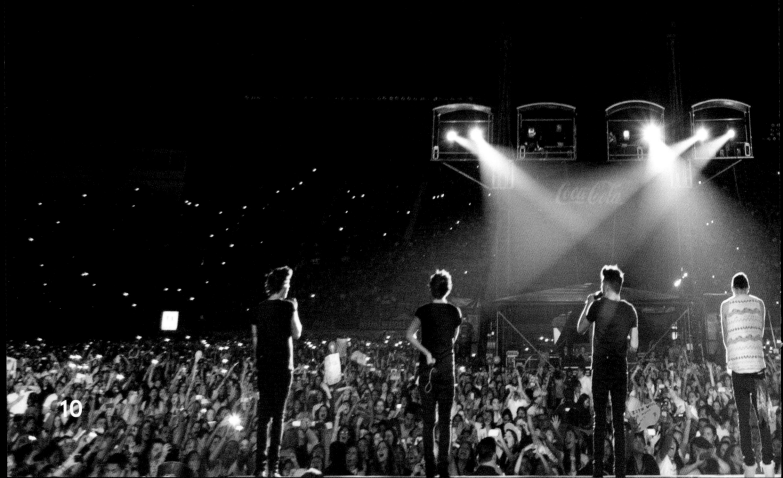

One Direction are the biggest band in the world right now. As well as selling out stadium gigs across the globe in seconds, they've become stars of the big screen in their own movie, *This Is Us*, and have continued to release chart-topping singles and record-breaking albums – not to mention clocking up billions of YouTube views for their award-winning videos.

With the release of *Midnight Memories*, all three of One Direction's albums have rocketed to the top of the charts across the world. But while their fame seems to have come so quickly, they've put an incredible amount of work into their success. Always touring, performing or recording, it's no wonder they've been entered into *Guinness World Records* and have won every award from the Nickelodeon Kids' Choice to numerous BRIT awards.

Other bands at this point might start to relax and take their feet off the pedal a little, but not One Direction. So many amazing things have happened to them, but they're still hungry for more. They know that only hard work will keep them at the top. Harry, Liam, Louis, Niall and Zayn are determined to keep on developing as artists and to give their careers and their fans everything they've got.

'It's been pretty amazing. I'm just really glad that I've been able to do what I love,' says Zayn.

Louis agrees: 'More has happened to us than we could ever have imagined. We owe it all to our fans. They're incredible and they've got us this far.'

It may have helped that One Direction came armed with some of the most fantastic pop songs ever written, but what their fans the world over really love is who they are. They're the kind of boys you can imagine hanging out with – the boys who everyone wants to be friends with. All five of them are genuine, down-to-earth lads who happen to be incredibly talented. Put this together with the drive and amazing strength of character they've shown in their careers so far, and there's no doubt that the sky's still the limit for One Direction.

TIME TO RELAX

EVEN POP STARS NEED SOME DOWNTIME...

Fame has come quickly to One Direction, but they've taken to it like naturals. Perhaps the most surprising thing about their success is that there's been no change in them. They're still the same fun-loving boys they've always been; stardom hasn't gone to their heads at all.

Life in the spotlight is exciting, but it's also incredibly tough. During tours, the boys have been known to max two hours' sleep a night. Life as a celebrity can become overwhelming and it's sometimes hard to hang on to yourself. But despite their huge success, Harry, Liam, Louis, Niall and Zayn have all remained remarkably normal. They're all incredibly close to their families and they still have their oldest friends with them all the way.

'My mates don't treat me any differently,' says Niall. 'They haven't changed a bit, and neither have I.'

In spite of all the perks of being a celebrity, Harry, Liam, Louis, Niall and Zayn still enjoy the same things

other lads their age do. They love the moments when, for a brief time at least, they are out of the spotlight and can still do ordinary things. They love going to the cinema to catch a funny movie, just hanging out with their friends, watching DVDs or TV, or just catching up. But a lot more planning goes into doing the ordinary stuff these days – as everywhere the One Direction boys go, pandemonium follows.

'You have to go about it the right way,' Niall says. 'Obviously it's not just a case of "Oh, I'm gonna go to this place for lunch." You *can* do all the regular things – you just have to think about it a bit.'

Each band member has their own interests that keep them busy. Harry loves art and fashion, and is regularly photographed on the front row at fashion shows. Louis loves football, Zayn loves drawing, Liam boxing and, as everyone knows, Niall really, really loves to eat. 'I like anything edible,' he jokes.

But no matter what they do – or where they are – they're always in touch with each other, and they can't wait to get back together and start working again. 'We're really close as a band,' says Niall. 'It's lovely to have time off, but it's always great to be back together.'

all about

Harry °

NAME: Harry Edward Styles

BORN: 1 February 1994
Redditch, Worcestershire, England

STAR SIGN: Aquarius

NICKNAME: H/Hazza

HEIGHT: 5 feet 10 inches

SIBLINGS: Gemma

LIKES: Tacos, Adele, Man United

DISLIKES: Olives, swearing, being rude to people

TWITTER: @Harry_Styles

DID YOU KNOW? Harry has dozens of tattoos all over his body. They include his sister's name, a pirate ship, two sparrows, an Iced Gem and a coat hanger.

'I love this job so much – if you can even call it a job'
Harry

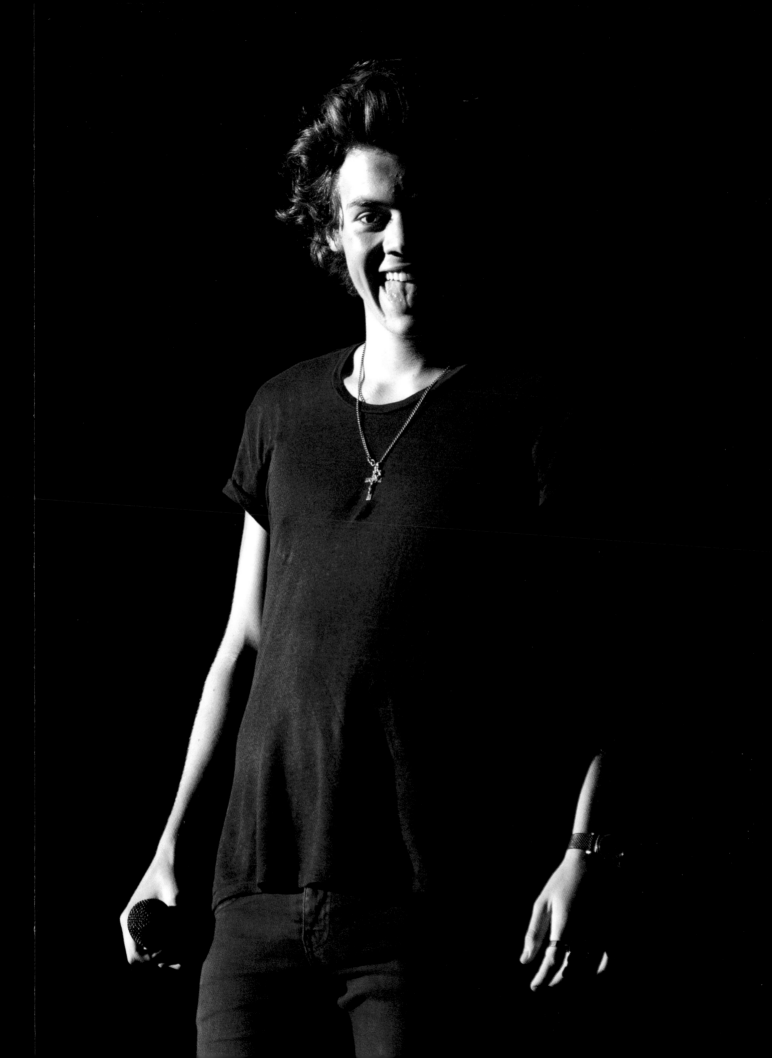

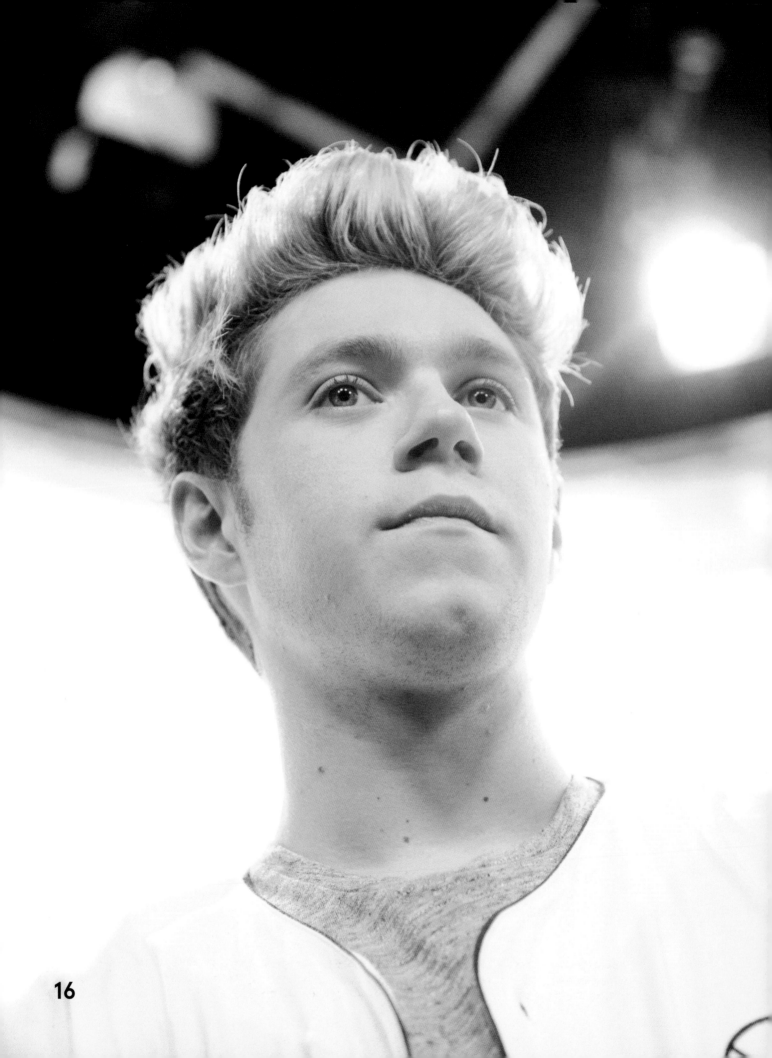

all about
Niall

NAME: Niall James Horan
BORN: 13 September 1993
Mullingar, County Westmeath, Ireland
STAR SIGN: Virgo
NICKNAME: Nialler
HEIGHT: 5 feet 7 inches
SIBLINGS: Greg
LIKES: Michael Bublé, giraffes
DISLIKES: Being hungry, dodgy chat-up lines, clowns
TWITTER: @NiallOfficial

DID YOU KNOW? Niall passed his driving test on his first attempt, after just 25 hours of intense training.

'Sleep till you're hungry – eat till you sleep'
Niall

all about

Liam

NAME: Liam James Payne

BORN: 29 August 1993
Wolverhampton,
West Midlands, England

STAR SIGN: Virgo

NICKNAME: Payno

HEIGHT: 5 feet 10 inches

SIBLINGS: Nicola and Ruth

LIKES: Chocolate, basketball
and singing in the shower

DISLIKES: Mean tweets,
spoons, flying

TWITTER: @Real_Liam_Payne

'It's so amazing to hear a crowd of people singing your songs. It's the best feeling' Liam

DID YOU KNOW? Liam has taken up the bass and is gradually getting better at it.

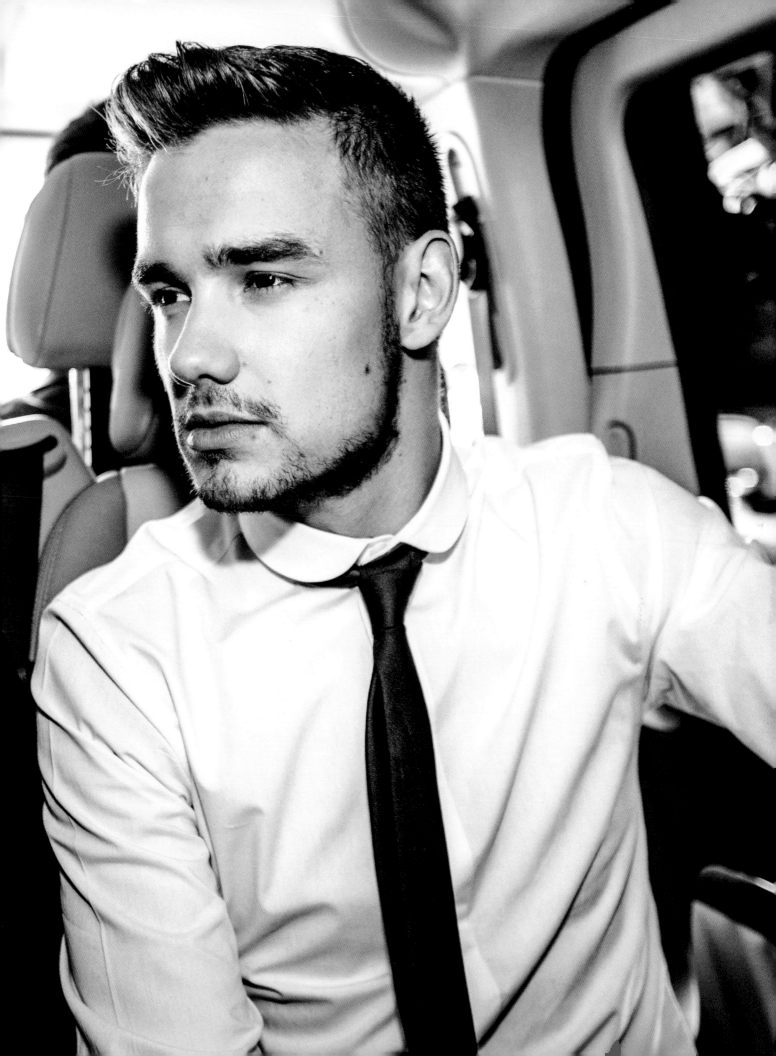

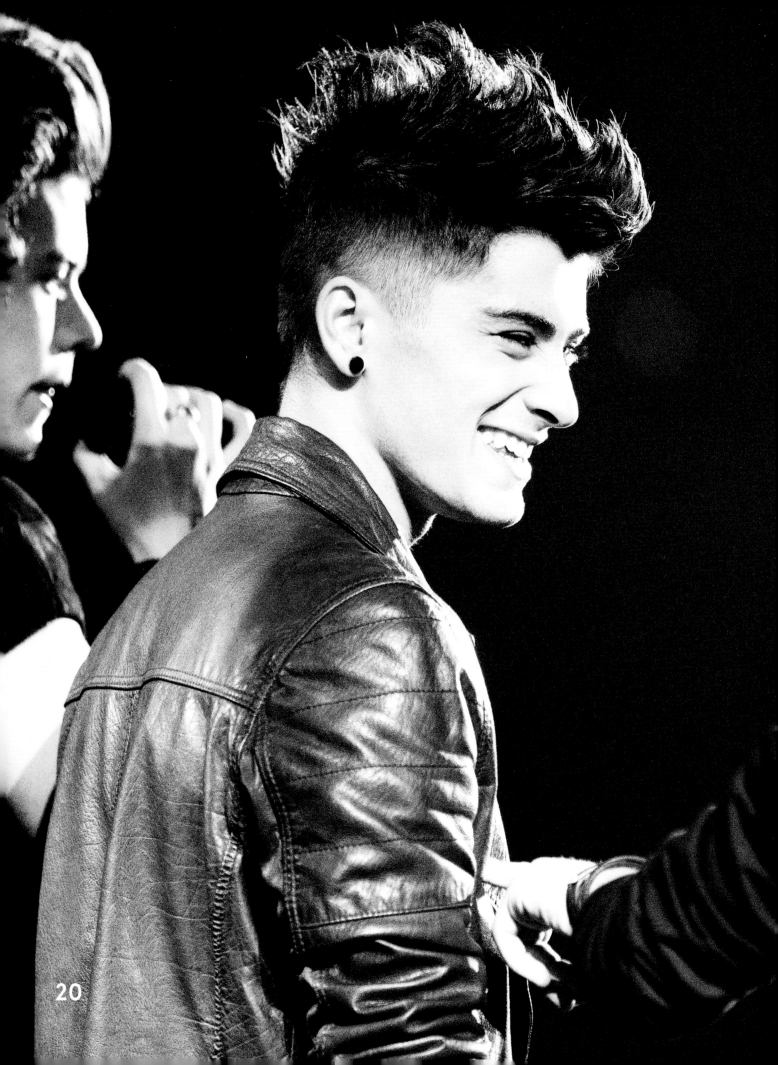

all about
Zayn

'I love the fact that I grew up wanting a brother and now I have four'
Zayn

NAME: Zayn Jawaad Malik

BORN: 12 January 1993 Bradford, West Yorkshire, England

STAR SIGN: Capricorn

NICKNAME: Z-z-zayn

HEIGHT: 5 feet 9 inches

SIBLINGS: Doniya, Waliyha, Safaa

LIKES: Tattoos, Chris Brown, *Family Guy*

DISLIKES: Pyjamas, sandwich crusts, swimming pools

TWITTER: @ZaynMalik

DID YOU KNOW? Zayn has fewer tattoos than Harry, but they're bigger. They include a full-size microphone and a crown to represent his surname, which means 'king' in Arabic.

all about Louis

DID YOU KNOW? One of Louis's favourite mottos is, 'Live life for the moment because everything else is uncertain.'

NAME: Louis William Tomlinson
BORN: 24 December 1991
Doncaster, South Yorkshire, England
STAR SIGN: Capricorn
NICKNAME: Tommo
HEIGHT: 5 feet 9 inches
SIBLINGS: Felicite, Lottie, Daisy, Phoebe, Ernest and Doris
LIKES: Macaroni cheese, cookie dough, partying
DISLIKES: Baked beans, not getting enough sleep
TWITTER: @Louis_Tomlinson

'We like to think we're rock and roll, but we're not really' Louis

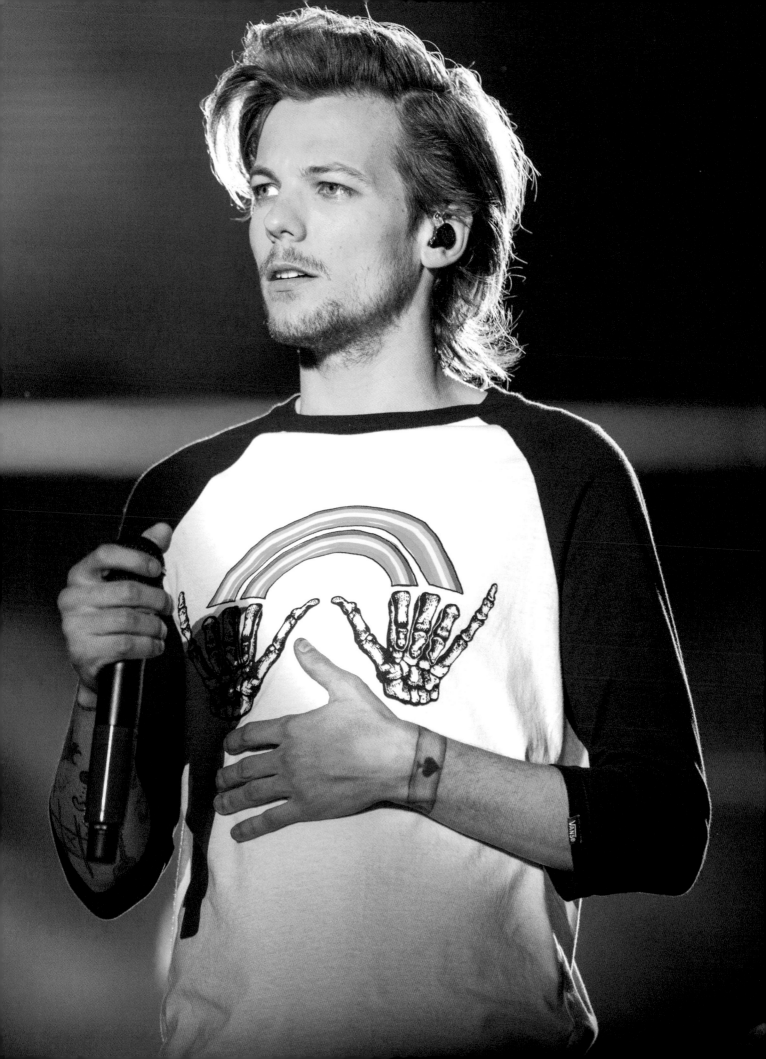

WHERE WE ARE

'THE GREATEST EXPERIENCE OF MY LIFE'

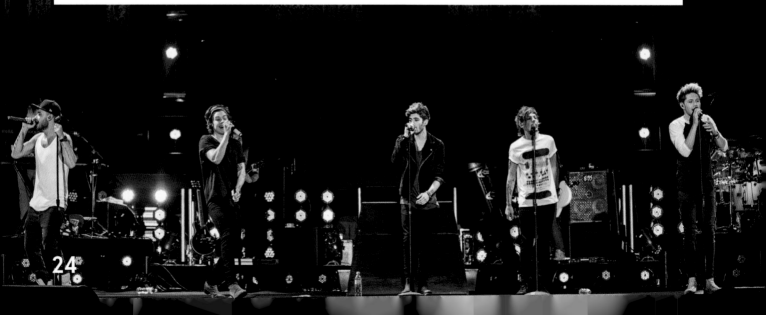

'We'll be remembered as the boy band who didn't dance,' laughs Louis.

As well as singing their hearts out, the band also entertained crowds by answering Instagram video questions during the show, leading to some hilarious moments. One of the best was in Peru when the boys burst into song after being asked about their favourite TV theme, leading to Harry, Liam, Niall and Zayn harmonizing to the *Friends* song (Louis had run off to the toilet beforehand!).

The crowd went wild, obviously loving every minute, visibly reducing the boys to tears.

'Our dreams came true because of you,' Harry told the fans.

Niall tweeted a picture of the boys as *X Factor* auditionees, saying, 'So grateful for everything. I can't believe these boys are playing a stadium tonight! Thank you so much! Love U!'

'The greatest experience of my life,' Louis tweeted afterwards, summing it up for them all.

The Where We Are tour was one of the most hotly anticipated tours in pop history, with tickets selling out in minutes. The tour saw One Direction deliver 69 dates across the globe, with very few nights off along the way. It was a gruelling schedule, but Harry, Liam, Louis, Niall and Zayn couldn't wait to get on stage.

Even though they've performed all over the world – and it's obvious to anyone who's ever seen them in concert that the boys are natural performers – they still get nervous before a gig.

'Every show is different,' says Harry, 'so you can never relax.'

But as soon as they walk out on stage, any fear is soon a distant memory and the boys give their performances everything they've got.

'There's nothing like it,' says Liam simply.

The shows were a non-stop fusion of lights, fireworks, lasers, flames, dry ice, explosions and super-massive screens, with the boys delivering their biggest hits to date, singing and jumping around in their own inimitable unchoreographed style.

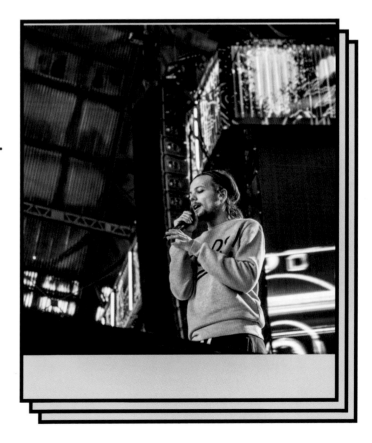

SET LIST

Midnight Memories
Little Black Dress
Kiss You
Why Don't We Go There
Rock Me
Don't Forget Where You Belong
Live While We're Young
C'mon, C'mon
Right Now
Through the Dark
Happily
Little Things
Moments

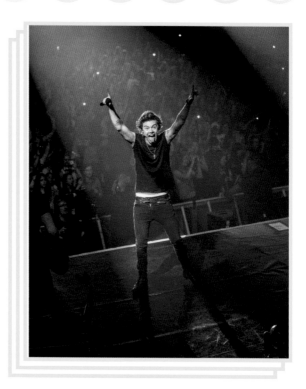

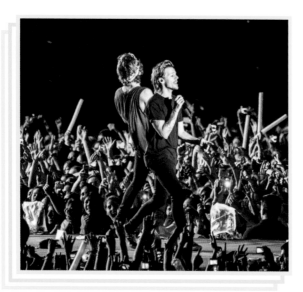

Strong
Better than Words
Alive
One Thing
Diana
What Makes You Beautiful
You & I
Story of My Life
Little White Lies
Best Song Ever

WHY WE LOVE ONE DIRECTION

THEY'RE DOWN TO EARTH

—

One thing's for certain: these boys are no divas. They don't even ask for anything particular backstage when they're on tour. 'We haven't actually got a rider,' Liam says. 'We're not really that diva. We never actually sat there and made one.'

THEY GET STAR-STRUCK

—

One Direction may be international stars with millions of Twitter followers, but they still get star-struck like everyone else. Niall admitted to being totally overcome when he met David Beckham. 'He's my footballing hero,' he said.

THEY LOVE A LAUGH

—

The boys' banter is legendary and they love nothing better than playing pranks. 'I'm always falling asleep when we're on tour and waking up to find straws shoved up my nose,' says Harry.

THEY'RE TRUE TO THEMSELVES

—

They're five of the most famous people on the planet right now, but they're still the same boys they always were. 'Things change, people change, but you will always be you,' says Zayn.

THEY DON'T MIND MAKING MISTAKES

—

Not everything goes perfectly. Harry once fell over an Oreo on a photoshoot, while Liam once ripped his trousers and flashed his underwear! 'That was stupid,' he laughs. Like true professionals, the boys know the show must go on no matter what happens – even if their cheeks are a little redder than normal.

THEY CAN STAND UP FOR THEMSELVES

—

The boys don't think twice when it comes to standing up for themselves or anyone close to them, whether in person or through Twitter. 'I'll always stand up for people I love,' says Niall.

THEY'RE THOUGHTFUL

—

All five boys like nothing better than looking after their family and friends. Harry brought his sister on tour, Zayn bought his mum a house, while Liam got his family a dog to keep them company while he's away. The boys all reckon being able to do things for others is the best thing about being in the band.

THEY LOVE LIFE

—

Harry, Liam, Louis, Niall and Zayn love everything about being in One Direction. They're determined to make the most of every minute. 'We're having the time of our lives,' says Louis.

THEY LOVE A BAD JOKE

DON'T BELIEVE US? READ THIS LITTLE LOT...

ZAYN: Why did the skeleton go to the movies by himself? He had no body to go with him.

LIAM: What do you get when you cross a pig and a cactus? A porky-pine.

HARRY: What did Zero say to Eight? Nice belt.

LOUIS: What do you get when you cross a snowman with a vampire? Frostbite.

NIALL: Why did the cookie go to the doctor? Because he was feeling crumby.

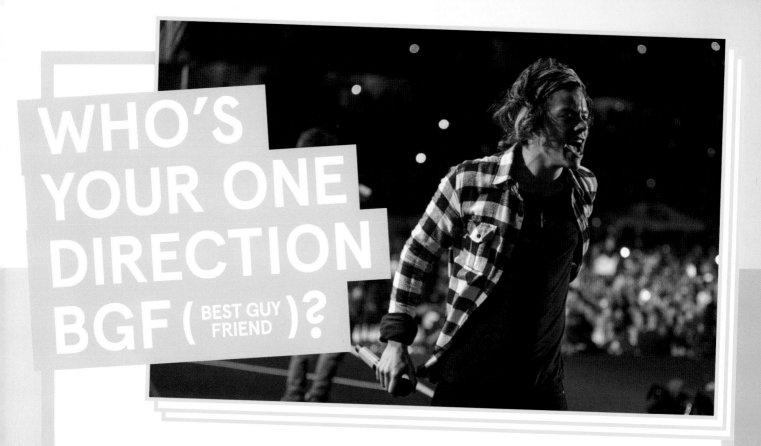

WHO'S YOUR ONE DIRECTION BGF (BEST GUY FRIEND)?

WHICH MEMBER WOULD YOU MOST MESH WITH? TAKE THE QUIZ TO FIND OUT WHETHER HARRY, LIAM, LOUIS, NIALL OR ZAYN WOULD BE YOUR BEST GUY FRIEND.

1. YOUR FAVE AFTER-SCHOOL ACTIVITY IS:

a) Playing football – you're always up for a friendly kick-about
b) Hanging out with your mates
c) Painting or drawing
d) Golf – it's not as easy as it looks
e) Having a karaoke session

2. YOU'VE HAD A LONG DAY – WHAT COMFORT FOOD WOULD MAKE YOU FEEL BETTER?

a) Cookie dough ... Mmmm
b) Any kind of choccie
c) Fried or roast chicken
d) Tacos would really hit the spot
e) Chinese take-away

3. WHEN YOU NEED ADVICE, YOU WANT YOUR BEST GUY FRIEND TO:

a) Be a good listener
b) Help you see the bright side
c) Have a good old heart-to-heart
d) Give you his honest opinion
e) Make you laugh out loud

4. WHAT SONG'S ON REPEAT ON YOUR PLAYLIST?

a) 'Look After You' by The Fray
b) 'Anything' by Jay-Z
c) 'Thriller' by Michael Jackson
d) 'Viva la Vida' by Coldplay
e) 'Free Fallin'' by John Mayer

5. THE MOST IMPORTANT QUALITY YOU LOOK FOR IN A GUY FRIEND IS:

a) A lad who's clever and funny
b) Someone who's up for adventure
c) A mate to joke around with
d) A boy who loves his family and friends
e) A guy who makes you ROFL

6. WHAT WOULD YOUR ULTIMATE BGF DO FOR YOUR BIRTHDAY?

a) Help you celebrate for a whole week
b) Watch *Toy Story* with popcorn
c) Give you a *Harry Potter* first edition
d) Organize a special dinner with your family and friends
e) Leave a whoopee cushion on your chair

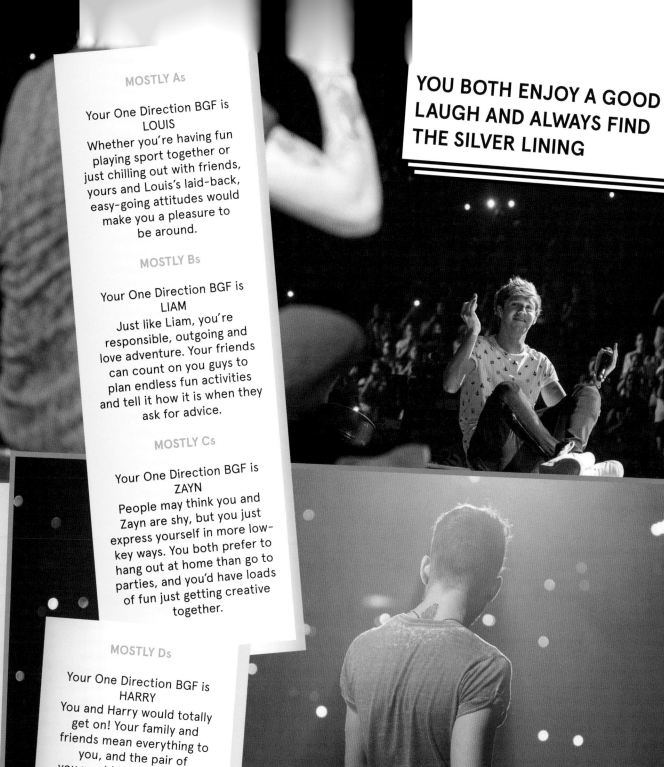

MOSTLY As

Your One Direction BGF is
LOUIS
Whether you're having fun playing sport together or just chilling out with friends, yours and Louis's laid-back, easy-going attitudes would make you a pleasure to be around.

MOSTLY Bs

Your One Direction BGF is
LIAM
Just like Liam, you're responsible, outgoing and love adventure. Your friends can count on you guys to plan endless fun activities and tell it how it is when they ask for advice.

MOSTLY Cs

Your One Direction BGF is
ZAYN
People may think you and Zayn are shy, but you just express yourself in more low-key ways. You both prefer to hang out at home than go to parties, and you'd have loads of fun just getting creative together.

MOSTLY Ds

Your One Direction BGF is
HARRY
You and Harry would totally get on! Your family and friends mean everything to you, and the pair of you would be the glue that holds your group of friends together.

MOSTLY Es

Your One Direction BGF is
NIALL
You and Niall would be the perfect pair of jokesters. You'd make each other crack up planning pranks on your friends. You both enjoy a good laugh and always find the silver lining.

YOU BOTH ENJOY A GOOD LAUGH AND ALWAYS FIND THE SILVER LINING

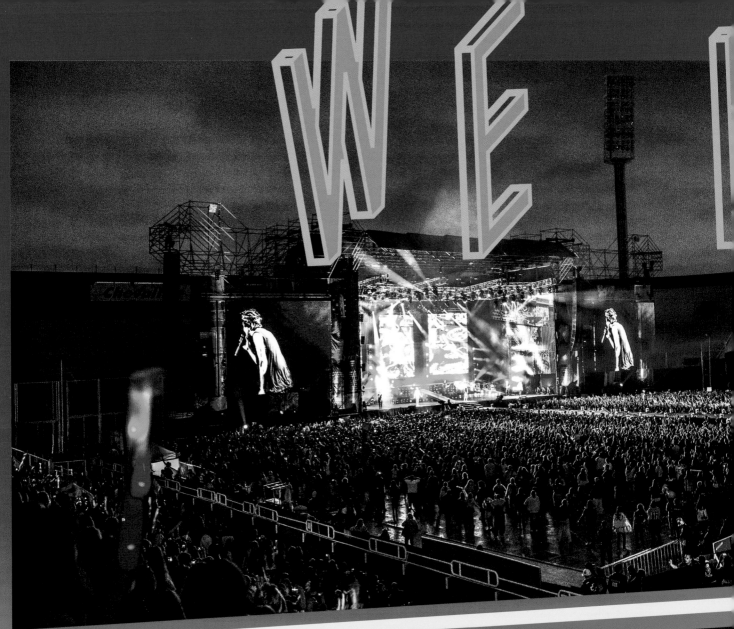

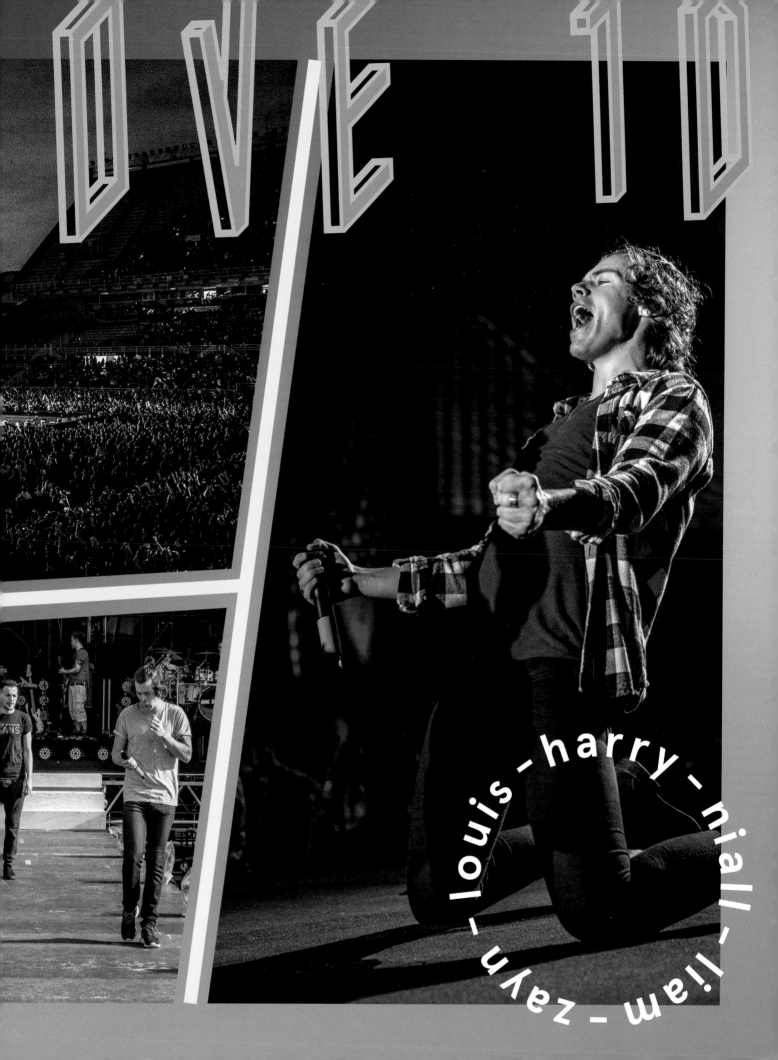

LIVE 1D

louis - harry - niall - liam - zayn

TEN SIGNS YOU'RE A ONE DIRECTION SUPER-FAN

OK, so you love everything about One Direction, but how deep does your devotion really go?

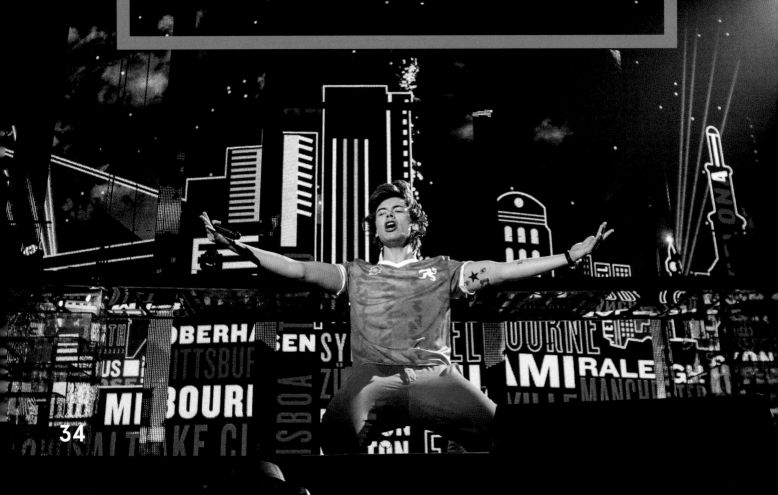

1
YOU RE-ENACT THE 'KISS YOU' MUSIC VIDEO

You've totally sat in your parents' car re-creating the scene with Louis and Niall from 'Kiss You'.

2
YOU KNOW EVERY SONG BY HEART BEFORE THE ALBUM'S EVEN OUT

You memorized the lyrics to every single track from their fourth album within 24 hours. And now you're impatient for the fifth already!

3
YOU NEED A WHOLE BOOKCASE FOR YOUR ONE DIRECTION FAN FICTION

You love writing fan fiction about the boys and your bookcase is simply groaning under the weight of all those used-up notebooks.

4
YOU UPDATE YOUR ONE DIRECTION TUMBLR MULTIPLE TIMES A DAY

It's safe to say you spend more time re-blogging insanely cute One Direction GIFs on Tumblr than you do sleeping.

5
YOU OWN EVERY ONE DIRECTION POSTER EVER PRINTED

Your wall is so covered in One Direction posters that you don't even remember what colour your bedroom wall actually is.

6
YOUR PARENTS NO LONGER WORRY WHEN THEY HEAR YOU SCREAMING

Screaming no longer means someone is in danger – just that there's a hot new piece of One Direction gossip online.

7
YOU RANDOMLY START SINGING 'BEST SONG EVER' ALL THE TIME

The phrase 'best song ever' will forever make you belt out 'And we danced all night ...'

8
YOUR PHONE IS COVERED IN ONE DIRECTION

Your phone case, phone background and ringtone are all One Direction. The same applies to your pencil case, make-up bag and school bag.

9
YOU'VE EXPANDED YOUR ONE DIRECTION VOCAB

You take pride in knowing all the lingo that comes with being a Directioner. But you especially love incorporating the One Direction guys into your new fave adjectives – phenominiall, amazayn, brilliam, fabulouis and extraordinharry!

10
YOU KNOW ONE DIRECTION BETTER THAN THEY KNOW THEMSELVES.

If you were up against them on *Mastermind* there's no doubt you'd beat the boys hands down in your One Direction knowledge.

ALL ABOUT THE MUSIC

THE BOYS ARE SERIOUS ABOUT MAKING THEIR MUSIC THE BEST IT CAN BE

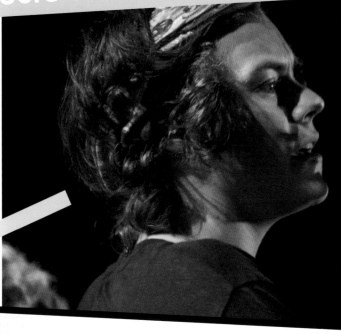

When the boys weren't busy on their Where We Are tour, Harry, Liam, Louis, Niall and Zayn spent most of their time in the recording studio, creating their next album.

The boys love every minute of being in the studio. It isn't a quick or easy process; writing lyrics and setting them to music, not to mention arranging them, takes a long time. As always, the boys were determined not to produce anything less than perfect, and they all wanted to be more involved in the songwriting process on this album. The band wanted the music to continue to reflect who they really are.

'Songwriting is a really cool thing, you know,' says Zayn. 'When you write your own music, that's special.'

The boys reunited with McFly's Tom, Danny and Dougie to write some music. Niall had a blast, tweeting: 'Just wrote another cool song with danny, dougie and tom! What a laugh that was.'

Harry

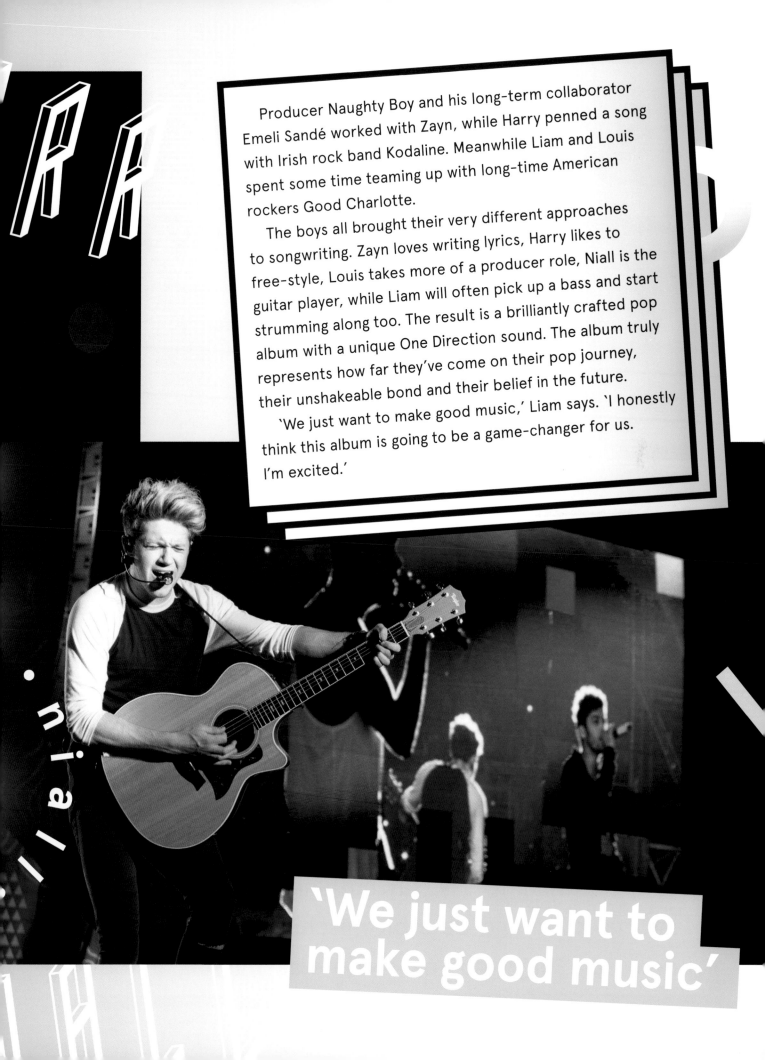

Producer Naughty Boy and his long-term collaborator Emeli Sandé worked with Zayn, while Harry penned a song with Irish rock band Kodaline. Meanwhile Liam and Louis spent some time teaming up with long-time American rockers Good Charlotte.

The boys all brought their very different approaches to songwriting. Zayn loves writing lyrics, Harry likes to free-style, Louis takes more of a producer role, Niall is the guitar player, while Liam will often pick up a bass and start strumming along too. The result is a brilliantly crafted pop album with a unique One Direction sound. The album truly represents how far they've come on their pop journey, their unshakeable bond and their belief in the future.

'We just want to make good music,' Liam says. 'I honestly think this album is going to be a game-changer for us. I'm excited.'

'We just want to make good music'

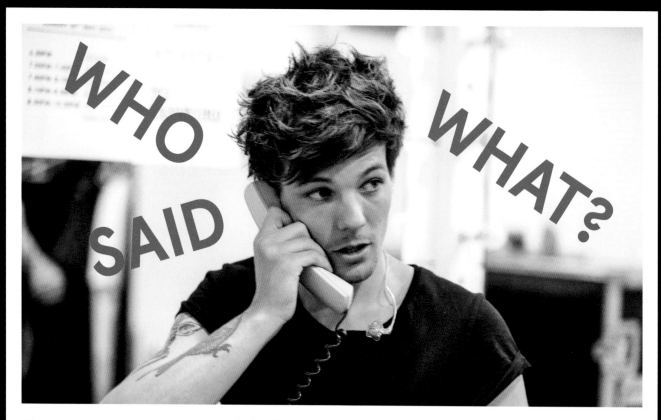

WHO SAID WHAT?

Can you guess which of the boys said the below?

1. 'I love the big red bus!' **2.** 'POTATO!!!!!!!!' **3.** 'If it were legal, I'd marry food.' **4.** 'Once I was taking a shower and heard a noise, so I opened the curtains and there was Niall sitting on the toilet. He just said "Hi".' **5.** 'I was going to say "great", but then I said "good", so I ended up saying "groot".' **6.** 'Just invited myself to a dinner tonight. In a relationship with myself.' **7.** 'You can usually hear me before you see me.' **8.** 'Got nothing to say, say nothing at all.' **9.** 'Live life fast, have fun and be a bit mischievous.' **10.** 'I came home one day and my turtle was missing a foot.'

11. 'Harry's nudity is contagious.' **12.** 'You always think there's someone missing in the band, because you never count yourself.' **13.** 'You pat the dog... you screw the light bulb... then you just go crazy.' **14.** 'Are you saying I'm not human?!' **15.** 'I had this dream that we had this new sixth member for some reason, and he actually ended up being quite horrible.' **16.** 'I wonder why Batman can't fly like Superman.' **17.** 'I'm a serious music lover.' **18.** 'Cats are evil.' **19.** 'Got me bus slippers on.' **20.** 'Let's go to Nando's!'

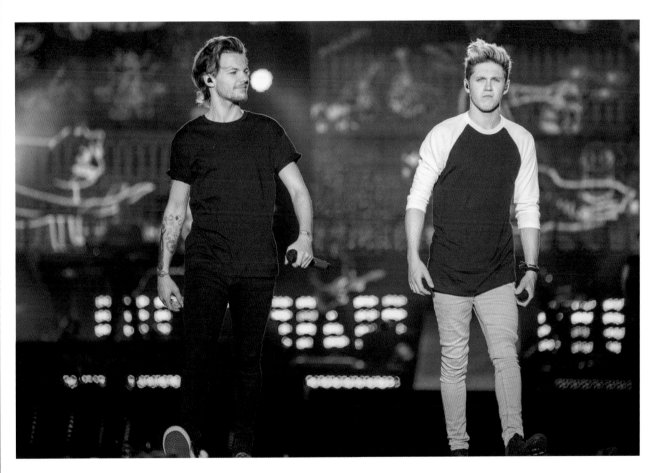

Exclusive Interview

LIAM

Q. Is there anywhere in the world you haven't been that you'd really love to play a gig?
A. I'm going to say the Moon. Let's do it!

Q. Which artists really inspire you?
A. I'm a huge Pharrell fan. What a guy, what a hat!

Q. What's on your personal playlist right now?
A. Erm ... a bit of Kanye, Jay-Z, Kendrick Lamar – that sort of thing.

Q. What makes you happiest?
A. I really do love being on stage, it's the most amazing feeling. I wish everyone could feel how amazing it is.

Q. Do you believe in fate?
A. I guess I do, yes. I just take every day as it comes, though. What will be, will be.

Q. What does being in One Direction mean to you?
A. Honestly, it's the most incredible thing. I mean, who wouldn't love travelling the world with their mates?

Q. What's the one thing you can't live without?
A. My phone. 100 per cent.

Q. What advice would you give your fans about following your dreams?
A. I would say, just go for it. Give it everything you've got.

Q. What dream would you still like to fulfil?
A. Oooooh, I'm learning to play bass at the minute. I'd like to get really good at that.

Q. What's your favourite item of clothing hanging in your wardrobe right now?
A. The lads'll tell you I'm a bit obsessed with hats at the minute – like, baseball cap ones. I've got loads but Louis keeps nicking them off my head during the shows and throwing them into the crowd. I'm gonna run out soon!

Q. Who do you follow on Twitter?
A. I follow quite a lot of our fans, actually – I love reading what they like and don't like about the show or new songs. It's a really good way for us to stay in touch with them.

Q. Describe your dream day off.
A. OK, so start with a reeeeaaallly long lie-in – no alarms, no Paul waking me up! Then I'd get up, maybe have a bit of brekkie, do a workout, and then I quite like going into the studio and playing with new tracks. It never feels like work when there's no deadline – you can just play until you get it right.

Q. What does the future hold for One Direction?
A. Oh gosh, who knows? We could never have predicted everything that's happened so far! We'll keep working hard and making the most of all the amazing opportunities our fans have created for us.

Q. Where's your favourite place in the world?
A. Home.

Q. What was the last dream you had?
A. Yesterday I had a dream about eating McDonald's. In a way it's bad, but it was nice to enjoy it without getting fat or feeling bad about unhealthy eating.

Q. How do you unwind?
A. It's always nice to hang out with the lads after the show – to just chat about stuff that happened, cool signs in the crowd and stuff. I like that time.

Q. What was the last photo you took?
A. A photo of the hotel floor number so I don't forget! Ha!

NIALL

Q. Is there anywhere in the world you haven't been that you'd really love to play a gig?

A. I love Australia. Any chance we get to go down there, I always jump at it.

Q. Which artists really inspire you?

A. I'm the biggest Eagles fan ever, I think.

Q. What's on your personal playlist right now?

A. A bit of John Mayer, and The Eagles, obviously.

Q. What makes you happiest?

A. Performing – 100 per cent. I love every second. I think you can see that when I'm on stage!

Q. Do you believe in fate?

A. I don't really think about it, if I'm honest. I guess, maybe I do?

Q. What does being in One Direction mean to you?

A. It just means everything. We're so lucky.

Q. What's the one thing you can't live without?

A. Music.

Q. What advice would you give your fans about following your dreams?

A. Just go for it, you never know what might happen.

Q. What dream would you still like to fulfil?

A. Winning a Grammy would be unbelievable.

Q. What's your favourite item of clothing hanging in your wardrobe right now?

A. Whenever we play in stadiums we often get given the local team's football or rugby jerseys. I've got a little collection going.

Q. Who do you follow on Twitter?

A. Lots of people! I'm into sport so I follow a few footballers and pundits, etc – I like hearing their opinions. Same with the fans – I like seeing their feedback.

Q. Describe your dream day off.

A. Sleep! Lots of it. Maybe a barbecue with mates on the new one I've just got – especially if it's sunny.

Q. What does the future hold for One Direction?

A. We could never have predicted the last four years so who knows what will happen in the future. If the last few years are anything to go by, it'll be amazing.

Q. How do you unwind?

A. Messing about on the guitar. I guess you might think when we're not on stage we'd want a rest from it, but the quiet time is when I get most creative!

Q. What was the last photo you took?

A. My dinner! Ha!

LOUIS

Q. Is there anywhere in the world you haven't been that you'd really love to play a gig?

A. I'm gonna say, back home in Donny.

Q. Which artists really inspire you?

A. Any good lyricist. It's a real talent to write powerful lyrics.

Q. What's on your personal playlist right now?

A. Biggie.

Q. What makes you happiest?

A. I think just doing what we love makes me pretty happy.

Q. Do you believe in fate?

A. Yeah, I think so.

Q. What does being in One Direction mean to you?

A. Well, it's just everything, isn't it? It's the best 'job' in the world.

Q. What's the one thing you can't live without?

A. My phone and FIFA.

Q. What advice would you give your fans about following your dreams?

A. Go for it, and don't listen to people who say 'can't'.

Q. What dream would you still like to fulfil?

A. To see Doncaster Rovers in the Premiership!!

Q. What's your favourite item of clothing hanging in your wardrobe right now?

A. I love my Vans. Vans every time for me.

Q. Who do you follow on Twitter?

A. A good mixture, I'd say. A bit of sport, music artists – obviously – and some of our fans.

Q. Describe your dream day off.

A. Oh, I'd just chill out at home, have a lie-in, some good home-cooked food – probably a Sunday roast – and watch a bit of footie on the telly.

Q. What does the future hold for One Direction?

A. Who knows? That's the fun of it.

Q. Where's your favourite place in the world?

A. Apart from home, Australia.

Q. What was the last dream you had?

A. Can't remember ...

Q. How do you unwind?

A. I like being on the tour bus – just chillin' out, playing PlayStation. It's nice to be with all the lads when you're winding down after the shows.

Q. What was the last photo you took?

A. One of my dog, Bruce.

ZAYN

Q. Is there anywhere in the world you haven't been that you'd really love to play a gig?

A. Somewhere hot. The Caribbean, maybe?

Q. Which artists really inspire you?

A. New artists inspire me – I like hearing new music and new ideas.

Q. What's on your personal playlist right now?

A. A lot of rap, weirdly, and Jhené Aiko's *Sail Out*.

Q. What makes you happiest?

A. Hanging with friends and family.

Q. Do you believe in fate?

A. I do, yes.

Q. What does being in One Direction mean to you?

A. It means being able to do what I love.

Q. What's the one thing you can't live without?

A. I'd have to say my phone.

Q. What advice would you give your fans about following your dreams?

A. Just give it a go, you never know what might happen.

Q. What's your favourite item of clothing hanging in your wardrobe right now?

A. Erm, maybe some Dr. Martens boots I've got. They're pretty cool.

Q. Describe your dream day off.

A. It's no secret that I like my sleep – so just lots and lots of sleep!

Q. What does the future hold for One Direction?

A. Who knows? We just take each day as it comes.

Q. Where's your favourite place in the world?

A. Bed.

Q. How do you unwind?

A. Sleeping.

Q. What was the last photo you took?

A. About 20 minutes ago I put one on Instagram of the Super Nintendo on the bus and the greatness that was *Mortal Kombat*.

HARRY

Q. Is there anywhere in the world you haven't been that you'd really love to play a gig?
A. Israel.

Q. Which artists really inspire you?
A. Chris Martin, Mick Jagger, Freddie Mercury.

Q. What's on your personal playlist right now?
A. Simon & Garfunkel, 'These Days' by Jackson Browne.

Q. What makes you happiest?
A. Sleeping, seeing friends.

Q. Do you believe in fate?
A. It depends on what context ...

Q. What does being in One Direction mean to you?
A. So much. Travelling the world, having fun and seeing fans at shows are the best parts.

Q. What's the one thing you can't live without?
A. Family.

Q. What advice would you give your fans about following your dreams?
A. Do what makes you happy.

Q. What's your favourite item of clothing hanging in your wardrobe right now?
A. My old Rolling Stones T-shirt.

Q. Who do you follow on Twitter?
A. An eclectic mix of people, I'd say.

Q. Describe your dream day off.
A. Sleeping in, Sunday roast with pals.

Q. Where's your favourite place in the world?
A. Home.

Q. How do you unwind?
A. I see friends and watch films.

Q. What was the last photo you took?
A. Harry Magee!

A Message from One Direction

It's been an incredible year for One Direction and – as ever – they know you've been there all the way. So here's a special message from them to you:

LOUIS: We say it all the time but we cannot say it enough – thank you, thank you, thank you, thank you! We owe everything to you.

ZAYN: We are so so grateful for everything that you do, you guys really are amazing!

LIAM: A huge, huge thank you. You guys are amazing, you really are!

NIALL: Thank you, guys! For supporting the music and coming to see us on tour, for tweeting, for your love, for your encouragement – everything. You are incredible - every single one of you!

HARRY: Not sure what I can add now. I guess just ... hello ... love you!

a-z

of

one

direction

A

Armbands. Zayn wore them in the video for 'Kiss You', as he still can't swim.

B

'Bradford Bad Boy' is one of the Zayn Meister's nicknames.

C

'Cheeseburgers and Jellybeans!' What Niall says in awkward situations.

D

Daddy Direction AKA Liam. He tries to keep all the boys on track.

E

Earrings. Zayn rocks two and we likey.

F

Football. Niall and Louis are huge footie fans. Niall reckons he was the most star-struck when he met David Beckham.

G

Glasses. Louis needs them and Zayn wears them occasionally.

H

Harry's hair. Surely the most famous curls in the world.

I

Ireland. The world can't get enough of Niall's accent.

J

Jay-Z. One of the few celebs who has left Liam star-struck.

K

Karen Payne AKA Liam's mum is the biggest worrier out of all the boys' mums. 'I don't think in the last three years I've seen Karen Payne without tears,' Harry says.

L

is for likeability.

M

Marrying Kate Beckinsale. Harry and Niall would both cast her as their film wife.

N

Nando's. The boys sure love their chicken.

O

Olympics. The boys sang at the closing ceremony in 2012.

P

Practical jokes. The boys are always playing them.

Q

Queues. Fans queue for hours, and the band are always happy to go out and talk to them.

R

Romantic. According to Niall, Liam and Louis are the most romantic guys in the group.

S

Superpower. Louis says if he could have any power, he'd like to be able to time-travel.

T

Tattoos. Only Niall hasn't been inked. Yet.

U

USP. Liam's suggestion for the band's name before Harry came up with One Direction.

V

Virgos. Niall and Liam were both born under this sign.

W

Wrestling. Zayn is the best arm wrestler out of the lot.

X

X Factor. Where it all began.

Y

Youngest. Harry's the baby of the band.

Z

Zzzz. Something the boys can never get enough of, especially on tour.

THE GIANT ONE DIRECTION QUIZ

How much do you know about One Direction? We challenge you to try our quiz and find out…

1. Whose birthday is closest to Christmas?

2. What is the only book that Niall says he's read all the way through?

3. On whose leg did Harry shave his initials?

4. What is the name of the online One Direction cartoon by animator Mark Parsons?

5. What was Harry's pet hamster called?

6. Who hates anyone stealing his food?

7. What superpower would Liam like to have?

8. Where was Harry born?

9. What was the first concert Niall ever went to?

10. What was One Direction's first ever single?

11. Who was attacked by a goat when he was young?

12. Which band member once drove around LA giving out pizza to the homeless?

13. Which judge was the group's mentor on *The X Factor?*

14. How many sisters does Zayn have?

15. What is One Direction's second album called?

16. What was the name of the single the boys recorded with their fellow *X Factor* contestants?

17. Which member of One Direction hasn't got a tattoo?

18. Who dressed up in a fat suit in a video and asked for hugs?

19. What are the names of Zayn's sisters?

20. Who grew up the furthest north?

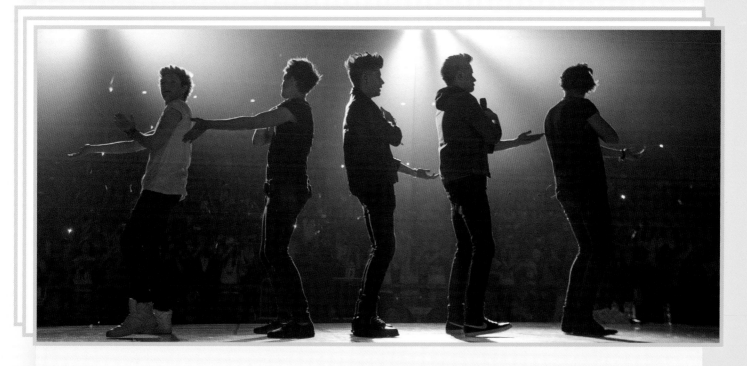

the ONE DIRECTION guide to friendship

These boys aren't just band mates, they're best mates too... so give your friendships a One Direction makeover

EMBRACE YOUR DIFFERENCES

'We've all got our own musical tastes and opinions,' says Zayn, 'but that's what makes it so great.' One Direction know that this is what makes them so unique.

TRUST EACH OTHER

One Direction trust each other absolutely. 'You've got to be able to confide in your friends,' says Niall. 'I'd trust these boys with my life.'

TALK IT THROUGH

When you do have a problem, Harry knows a better solution than arguing. 'We try to be mature. We have a chat, then move on,' he says. 'It's the best way to be.'

APPRECIATE YOUR MATES

Remember why you love your friends, then let them know. 'We're all band mates but our friendship comes first,' Zayn says. 'When we're not together we're constantly texting to say, "Hey, I miss you."'

BE HONEST

Niall's number one rule of friendship is simple: real talk. 'We're so truthful with each other,' he says.

KEEP CALM

Even when your friends get on your nerves, try to keep it in check. 'We don't really argue,' says Louis. 'No one believes us but it's true. We might disagree about whose turn it is on the PlayStation, but that's about it.' One Direction know it's not worth the fuss.

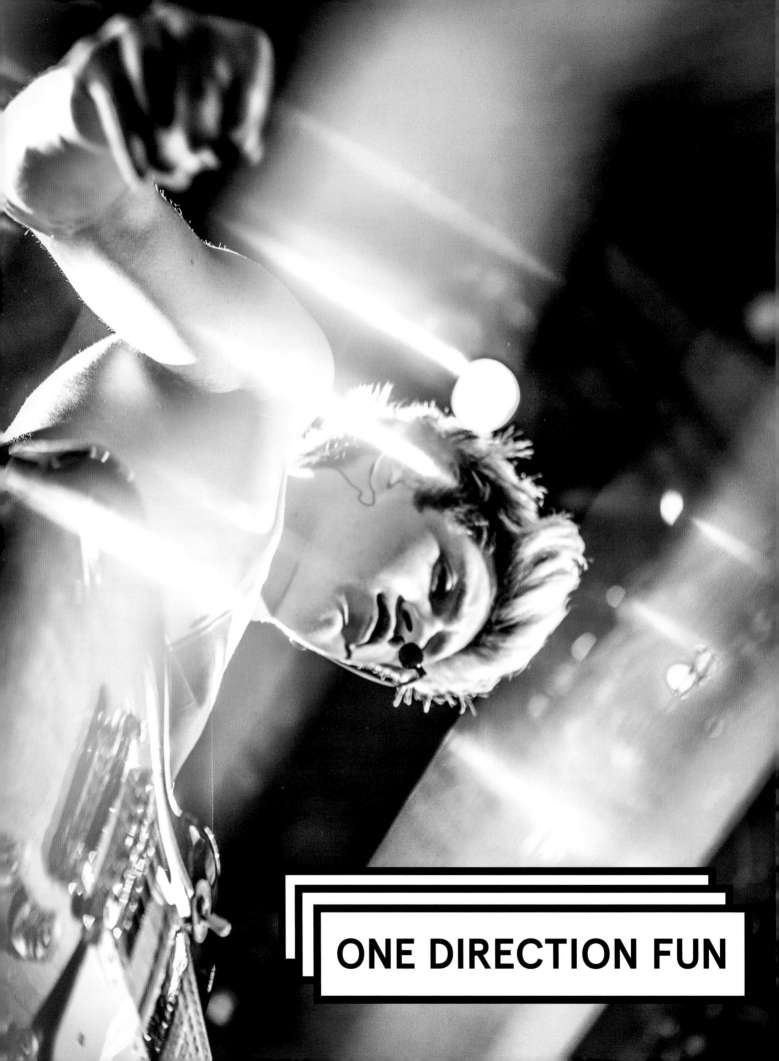

ONE DIRECTION FUN

CAN YOU FIND ALL THE ONE DIRECTION WORDS HIDDEN IN THE GRID?

P E R F O R M I N G T F K L W
N E M C X G W Z Z F N R Q I O
I C I B L F P V C A X I K A A
X L X L S N A F D Z Y E Y M G
P Z A W M C O S H V G N R C P
W I J Q U H I H D N Q D R B S
N H V M Q C M S I W Y S A H D
S F E Z J W O T U T B H H C R
L D Y R N Q I Y O M P I Q J A
Q S Z B E R E U D P I P O E W
T K A P W W R L O U I S W G A
Y N Y G C I E K Y Z V V A V K
D E N Z N G M A R O T C A F X
K O J G A R F U R O A P S S X
S A L A Y N F X R E L U Q N Z

AWARDS / MUSIC / HARRY / NIALL / ZAYN / LIAM / LOUIS / TOURING / BAND / FANS / PERFORMING / WHERE WE ARE / FRIENDSHIP / SONGWRITING / X FACTOR

ONE DIRECTION'S
favourite things

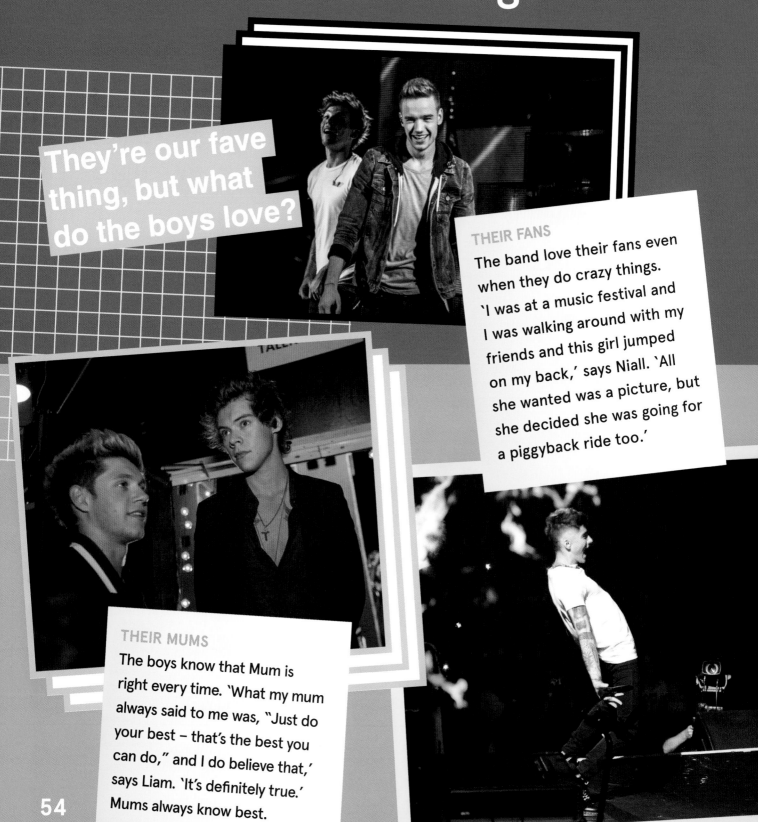

They're our fave thing, but what do the boys love?

THEIR FANS

The band love their fans even when they do crazy things. 'I was at a music festival and I was walking around with my friends and this girl jumped on my back,' says Niall. 'All she wanted was a picture, but she decided she was going for a piggyback ride too.'

THEIR MUMS

The boys know that Mum is right every time. 'What my mum always said to me was, "Just do your best – that's the best you can do," and I do believe that,' says Liam. 'It's definitely true.' Mums always know best.

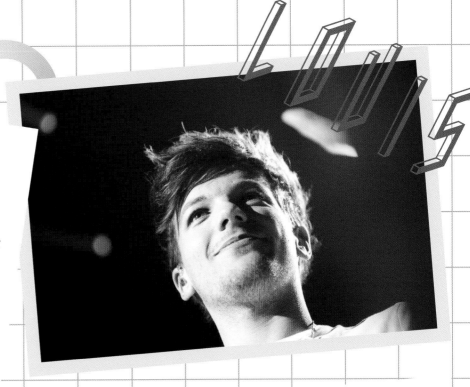

NO ALARM CALLS

The boys reckon the best thing about going home is not having to get up early to go to work. 'I'll just watch TV with my family and fall asleep,' says Harry. 'It's just nice to fall asleep and know you don't have an alarm set on your phone.'

PRANKS

Every One Direction fan knows that the band are big pranksters, but contrary to popular belief they really don't prank each other. 'We prank everyone who works with us, like our team and stuff like that,' clarifies Niall. 'Our musicians who play in the band for us – we once taped up their door so they couldn't get in the dressing room,' laughs Harry.

OTHER BANDS

All the boys are big music fans and love checking out other bands and performers whenever they can. 'It's what we used to do before all this,' says Niall. 'I love seeing other people's gigs.'

55

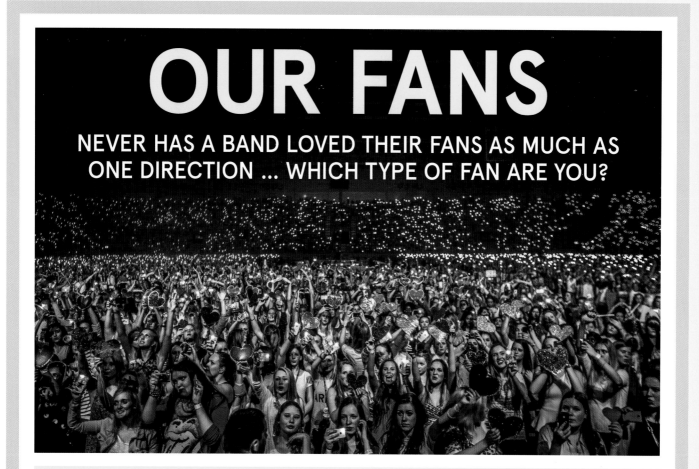

OUR FANS

NEVER HAS A BAND LOVED THEIR FANS AS MUCH AS ONE DIRECTION ... WHICH TYPE OF FAN ARE YOU?

OBSESSIVE DIRECTIONERS - These fans go to the boys' houses and wait outside for them to return home – as well as follow them all around the world **THERE FROM THE START FANS** - These are the fans who watched the boys' very first auditions on *The X Factor*. They even remember what each boy was wearing to his very first audition. **CREATIVE FANS** - Many of One Direction's fans are incredibly talented. Some have drawn amazing life-like pictures of the boys, while others express their talent in writing. **LOYAL FANS** - These fans have posters on their walls and check the One Direction Twitter updates daily, as well as listen to their album on repeat.

Whichever category you fall into, Harry, Liam, Louis, Niall and Zayn love you!

'Every fan is so special to us,' says Zayn. 'I love being in the studio, but not as much as I love performing live, because that's when we get to connect with our fans.'

And even after all this time, the band still struggle to understand just how huge their fan base is.

'I will never understand, and you will understand what this does to somebody... why? No one could deserve this,' Liam tweeted recently.

Harry agrees, summing it up for all of the boys. 'At the end of the day our fans are our everything and they got us to our position,' he says. 'They're our family.'

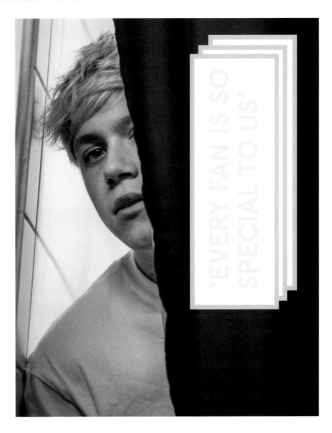

'EVERY FAN IS SO SPECIAL TO US'

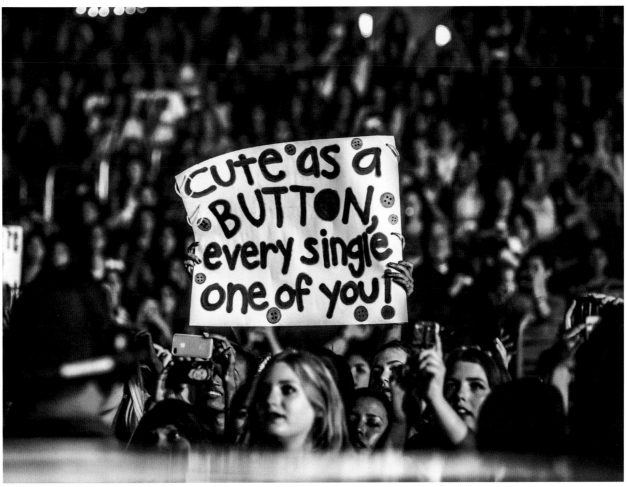

Did You Know?

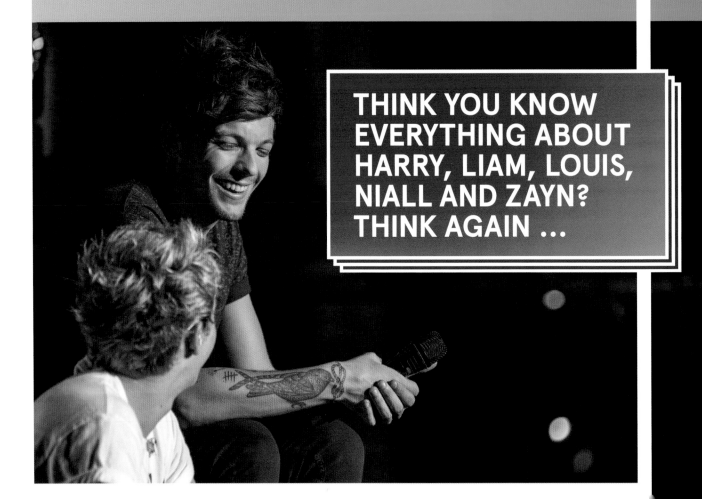

THINK YOU KNOW EVERYTHING ABOUT HARRY, LIAM, LOUIS, NIALL AND ZAYN? THINK AGAIN ...

At the age of ten Harry was attacked by a goat.

If Liam could invent an ice-cream flavour it would be Krispy Kreme donut.

Zayn used to eat paper.

Louis once revealed that he used to entertain himself when bored by poking Harry in the face!

The music video for 'Best Song Ever' was co-written with comedy star James Corden.

When naming One Direction, Niall suggested they should be called Niall and the Potatoes.

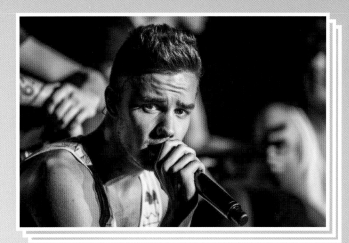

Niall says that he was most star-struck when he met David Beckham.

The craziest thing Liam has ever eaten was the fish he caught in *This Is Us.*

Liam broke a toe by dropping a computer on it.

Zayn loves comic books.

If Zayn was going to get stranded on a desert island he'd take Louis with him.

Niall never went to his school prom.

The boys once sent Simon Cowell a birthday card with £2.50 in it – 50p from each member.

Harry used to have a hamster called Hamster.

Niall's least favourite subject at school was Geography.

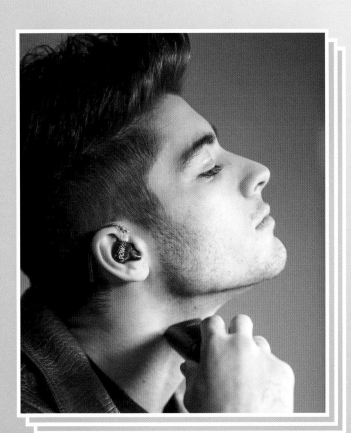

THE FUTURE

THEY HAVE THE WORLD AT THEIR FEET, SO WHAT'S NEXT FOR THE FABULOUS FIVE?

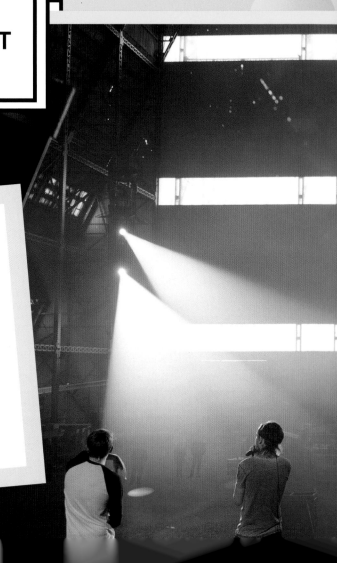

Can anyone even remember a time when they hadn't heard of One Direction? Looking at everything One Direction have achieved it's easy to forget how young they still are and how far they've come in such a short while.

'We're definitely older and wiser,' says Niall. 'We've had to learn quickly. We're just normal boys who make the same mistakes as the next person.'

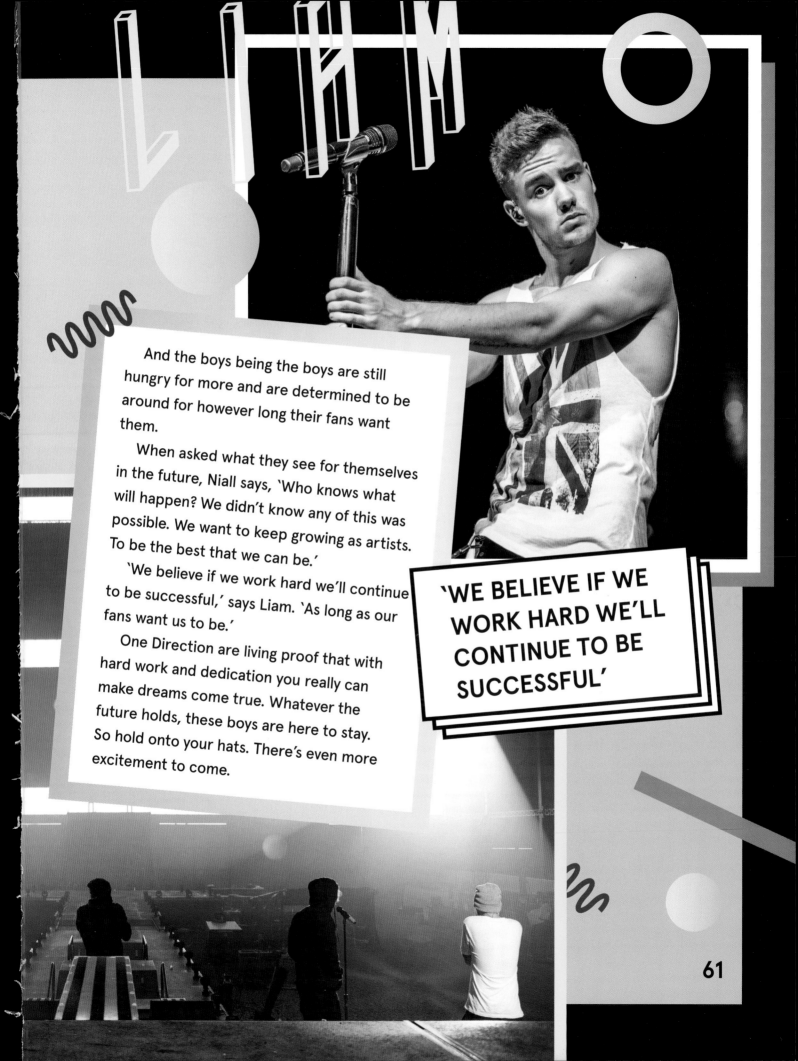

LIAM

And the boys being the boys are still hungry for more and are determined to be around for however long their fans want them.

When asked what they see for themselves in the future, Niall says, 'Who knows what will happen? We didn't know any of this was possible. We want to keep growing as artists. To be the best that we can be.'

'We believe if we work hard we'll continue to be successful,' says Liam. 'As long as our fans want us to be.'

One Direction are living proof that with hard work and dedication you really can make dreams come true. Whatever the future holds, these boys are here to stay. So hold onto your hats. There's even more excitement to come.

'WE BELIEVE IF WE WORK HARD WE'LL CONTINUE TO BE SUCCESSFUL'

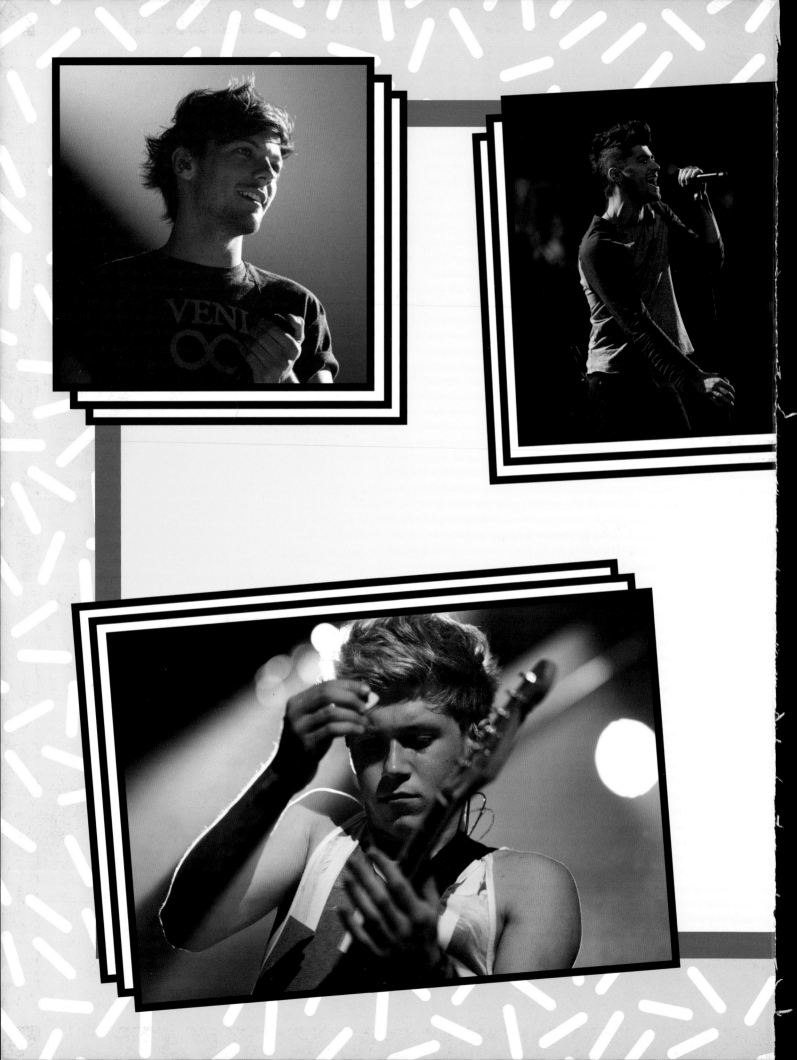